How to
UNDERSTAND,
ENJOY, and DRAW
Optical
ILLUSIONS

37 Illustrated Projects

Pomegranate
SAN FRANCISCO

Robert Ausbourne

Published by Pomegranate Communications, Inc.
Box 808022, Petaluma CA 94975
800 227 1428; www.pomegranate.com

Pomegranate Europe Ltd.
Unit 1, Heathcote Business Centre, Hurlbutt Road
Warwick, Warwickshire CV34 6TD, UK
[+44] 0 1926 430111; sales@pomeurope.co.uk

Library of Congress Cataloging-in-Publication Data

Ausbourne, Robert.
 How to understand, enjoy, and draw optical illusions / Robert Ausbourne.
 p. cm.
 ISBN 978-0-7649-4194-8
 1. Optical illusions--Handbooks, manuals, etc. I. Title.
 QP495.A93 2007
 152.14'8--dc22
 2007009647

Designed by Mariah Lander

Pomegranate Catalog No. A140

Printed in China
16 15 14 13 12 11 10 09 08 07 10 9 8 7 6 5 4 3 2 1

For
ANTHONY ANTOINE AZEVEDO
Among the faithless, faithful only he.

Many thanks to the Pomegranate editors.
With special thanks to Theresa Duran for making me
look like I know what I'm talking about.

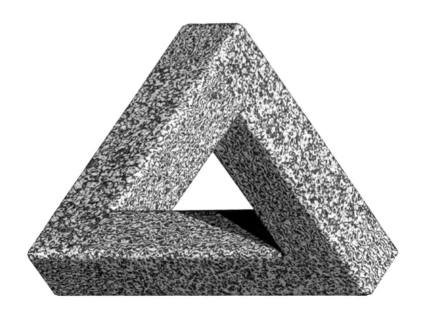

CONTENTS

INTRODUCTION

This manual explores a wide variety of optical illusions from an artist's or designer's point of view. In graphic terms, we will look at how illusions work and how to draw them. The book offers plenty of tricks and tips, plus illustrated examples and many step-by-step projects to help along the way.

If you enjoy optical illusions, or want to increase your enjoyment of them, you will benefit from the journey. I hope that artists will find inspiration along this book's path. Other adventurers may discover interesting ways to build new skill sets. Teachers and instructors may find new material to use in classrooms, shops, and the studio. But you don't have to be an artist or a rocket scientist to appreciate optical illusions. Simply follow along with the explanations and wander through the numerous examples. Before long you'll shout, "Hey, look at this!" and know a little bit more about the subject.

What do you need to know about optical illusions? Not much. You will find no deep science here. The explanations of the visual effects are intentionally uncomplicated. The manual is divided into convenient sections, so it's easy to look for illusions that interest you. Those wishing to dip more than a toe into the science of illusions may want to consult the suggested readings listed at the end of the book.

If you are human, you already have the basic skills necessary to study and create illusions. You will do just fine. Serious artists should know where the pointy end of a pencil is. A sense of color, a dash of perspective, a way with shapes, and a careful eye won't hurt either. This book is not meant to be an introductory drawing course, even though the projects are easy to follow. The main idea is to have fun. We will deconstruct impossible objects, cavort with color, frolic with distortions, and do the boogie with ambiguity. We'll do magicians one better by creating magic without sleight of hand, or smoke and mirrors. We'll do it all with nothing up our sleeves but dirty elbows and the true, visible magic of line and form.

DESIGNER'S NOTES

Adobe Photoshop is mentioned several times because it is my image processor of choice. Most projects can be completed using traditional drawing tools. However, an image processor can make life so much easier. The Photoshop commands and filters used are very basic, and other popular image processors likely have similar options.

Always remember that illusions can deceive the artist too. This can be maddening when you are working on a design that keeps blinking, fading, changing colors, or spinning in place. Sometimes you may become illusion-proof. You'll swear that you can't see the illusion at all or that it is too easy to see. Your tendency will be to make the illusion harder or easier to spot. Take a break instead. Fresh eyes will help you to see the illusion as viewers will.

Illusions start working when least expected, and once working, there is no ignoring the effects. You may stare at one point, while the design does cartwheels in the corner of your eye. This happened to me while working on a pinwheel design. At one point I thought, "Shoot, I'll have to wait for it to come back around. . . ." Duh! It's not really moving! I actually laughed out loud and looked around to see if anyone was looking.

Not everybody sees illusions in the same way. Many factors are involved. Literally everything we see or have seen, and everything we know or assume, is in the mix. Children see many illusions with such clarity and lightning speed that they often remark, "Yeah, so?" By contrast, older folks often have trouble seeing the same illusions. Consider your audience. It's a cinch that little green aliens would be a tough crowd.

A story about the discovery of a tribe of natives illustrates this point in the extreme. The tribe had lived for many generations in a remote, dense forest with no contact with the outside world. They had never seen a horizon and could not even visualize one. Thus, when a few of the men were taken to visit an open plain, they immediately became confused by the unrestricted view. They refused to believe that a herd of wildebeests grazing in the distance were bigger than mosquitoes! The natives were suckers for a spatial illusion because they never learned a skill that we take for granted.

Lastly, remember that illusions are not harmful to the eye or mind. In fact, research shows that illusions may be beneficial to healthy vision, and certainly to learning in general. In some cases, they have been useful in therapy for improving vision problems.

CHAPTER 1
Afterimage Illusions

Afterimages are illusions that develop in the mind's eye and fade quickly. Because these images are ethereal, existing only as mental perceptions, they cannot be drawn. However we can generate them until the cows come home. In this section we will be working with afterimage generators, or AIGs.

Each of us has billions of light receptors in our eyes, which gather data from the outside world. To create an afterimage, we first need to charge up a few million of our receptors with a target image. That is, stare at the target until the light receptors are fatigued.

After charging, the next step is to set the stage for the afterimage to appear. Look quickly at a neutral surface such as white. This will force the receptors to shift into neutral. As the charge fades, the receptors will continue to transmit diminishing signals to the mind's eye. The effect is similar to that moment in a boat race when the coxswain yells, "Oars up!" The scull continues to skim forward even though the oarsmen are at rest. The mind's eye develops these weak signals as afterimages.

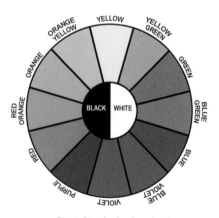

Fig. 1. Standard color wheel

A hard rule of afterimages is that they always appear in the exact opposite, or complementary, color. All the colors that we can see represent various mixtures of red, green, and blue light. All three of those colors together in equal quantities make white. If you "tank up" on green and then look at a white surface, you are looking at all three colors, but with fatigued green receptors. The result can be expressed mathematically as red plus blue plus reduced green, which equals a purplish pink color. If you drench your photoreceptors in red, the result would be a blue-green color.

Every color has an opposite, complementary color. Use the color wheel in Figure 1 to help locate opposite colors for projects. Locate a target color, then find the afterimage color directly

opposite on the wheel. Your afterimage generator can have any number of target colors. It all depends upon how complicated you want it to be. The wheel itself is an afterimage generator. Try it. You should see all the colors backwards.

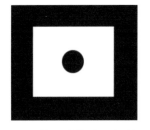

Figure 2. Black-and-white afterimage generator

Experiment with the AIG in Figure 2. Charge up on the black dot (stare at it), then look at the black square on the right. A fuzzy gray dot will appear. Try it again, but this time look afterward at the white area outside. Is the dot brighter? Yep.

About charging times: Figure 2 will charge in about ten seconds. More complicated afterimages may require a slightly longer charge time. Charging for longer than thirty seconds isn't harmful; you are merely giving your receptors a better workout. However, the afterimage probably won't be any stronger or last longer.

I've seen AIGs that ask you to stare at a target for up to two minutes. If your generator requires a two-minute charge, get a clue! The only thing worth staring at for two minutes is a Zamboni ice machine. Good afterimage generators have short charge times and maximum aftereffects.

How to look at afterimage generators: Relax and let it happen. Don't move your eyes too much. Try to look at the whole image at once. My personal technique is to imagine myself stuck in summer school, bored to death, staring out the window at nothing at all. Apparently I spent a lot of time in this position, because it comes naturally.

Drawing afterimage illusions is a matter of putting the wrong colors in the right places. It is a very odd way to draw. To make green aftereffect trees, color them in shades of red. A yellow sun has to be violet. White snow needs to be black, and blue skies need to be orange.

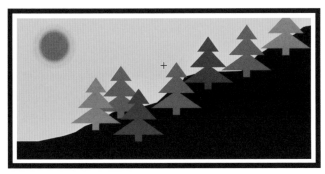

Figure 3. Snow scene AIG

Figure 3 shows a simple afterimage generator in appropriate complementary colors. The afterimage of this scene will reveal a snowy slope with green trees, blue sky, and a yellow sun. A cross in the image indicates the spot most comfortable to look at when charging. A ten- to fifteen-second charge will do nicely.

Question: In order to make a red heart appear, what color should the heart be in an afterimage generator?

Answer: A variety of green hues will work.

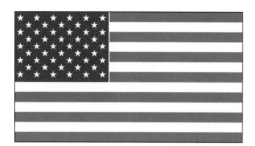

PROJECT 1
Color-Reversing Flag

This project will build an afterimage generator for the American flag in its proper colors. Instead of red, white, and blue, we'll root for the old green, black, and orange!

Fig. 4a. American flag template

The first thing we need is an outline of Old Glory. If you don't have one, you can use Figure 4a. Scan, copy, or trace the outline and use it as a template. (I shudder to think of you cutting up this book.)

Now let's begin adding color to our generator. We will ignore the black outlines in our template because they will turn white in the afterimage and will not be visible. Color in the stripes that should be red in the afterimage with green, as shown in Figure 4b.

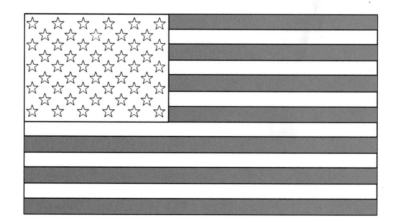

Fig. 4b. Use green for a red afterimage

The remaining stripes and stars on a US flag are white, so we'll need to color them black in our generator. Use Figure 4c as a guide for coloring the white areas.

The only remaining color in the US flag is blue, and we now know that orange will generate blue in an afterimage. Use orange to fill in the background behind the stars and complete the afterimage generator.

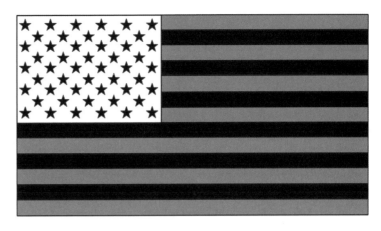

Fig. 4c. Use black for a white afterimage

A full-size US flag AIG is shown in Figure 4d. A charge time of ten to fifteen seconds will develop a fairly strong afterimage illusion of a US flag with traditional red, white, and blue colors.

Use this same technique to make an afterimage generator for almost any world flag. Simply create an outline of the flag and use the standard color wheel to plot its afterimage colors.

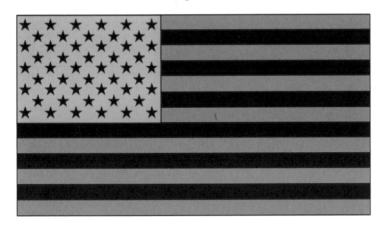

Fig. 4d. Completed color-reversing flag

Digital tip: Photoshop can be used to turn any picture into an afterimage generator. In an active layer, simply select Image > Adjustments > Invert. It's that easy. The image handler will automatically invert all colors to their exact opposite afterimage colors.

PROJECT 2
Spattered Paint

Some afterimage illusions require no conscious charge time at all. You don't even have to stare at any one spot. The afterimage just happens while you look at the picture. Here is how to make a "real-time" afterimage illusion.

If you can dip a brush into paint, you can draw this illusion. It is very simple to do and powerful enough to work with a wide range of color combinations.

Drip some paint on a piece of paper or canvas. That's it. You're done. Choose a color based on the afterimage color you wish to develop.

Figure 5 shows an example of the illusion using blue dots on a neutral gray background. This half-white and half-black shade of gray is neutral because its opposite is identical in an afterimage. As you gaze around the image, look for fuzzy yellow dots to form between the blue ones. The background color will remain constant.

This effect would work just as well on a white background. To test this out, stare at the image for a few seconds, then glance at the white areas of the page. The neutral gray color disappears, and the fuzzy yellow dots now appear slightly brighter.

What would happen if we changed the background color to black? The effect would look the same! The black background would turn white and disappear, while the blue dots would still turn fuzzy yellow.

Experiment with different background colors and see what happens.

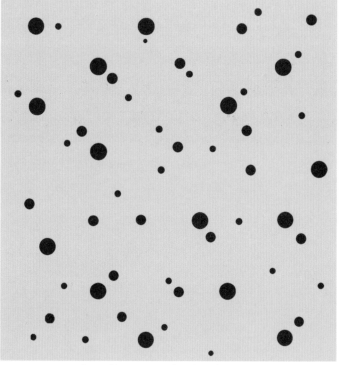

Fig. 5. Blue spatter with yellow afterimage

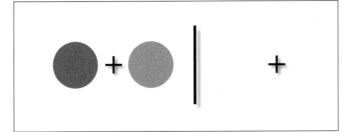

PROJECT 3
Effective AIGs

Here is a great afterimage generator that can be used for a wide range of color testing, flash cards, or simply for fun. The illusion is very easy to do and very effective, requiring a short charge time (about five seconds).

The AIG consists of two crosses divided by a vertical bar. One cross sports a pair of colored dots. The other cross is surrounded by empty space, where the afterimage should appear. Figure 6a shows an example of the illusion.

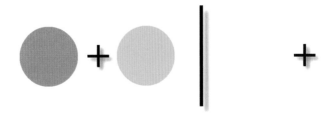

Fig. 6a. Blue and green afterimage generator

The object is to charge up on the color-flanked cross, then look directly at the cross on the other side of the card. For a few seconds during the "show," the card will have four colorful dots: the two originals plus two harmonious and completely illusory afterimage dots. The trick is to try to guess the visiting colors before they appear.

Consider the illusion in Figure 6b. Before you test this generator, try to guess what will happen to the two target colors in the afterimage. The target colors are both black mixed with white in different quantities. The opposite of black is white.

Will both dots stay the same? Will they turn white? Are they visible over the background? Can one white be whiter than another, or are these colors shades of gray?

Fig. 6b. AIG for two shades of white

PROJECT 4
Full-Color AIGs

You can make an afterimage generator out of any ordinary full-color picture simply by making a negative image of it. Negative images appear in the exact opposite colors that are visible in the picture itself.

This project shows how to easily make an AIG out of almost any image using popular software. Photoshop is my digital image editor of choice, and fellow users may recognize the simple commands used. Even if you use a different program, your favorite image editor may have similar features.

The first step is to choose a picture for the project. I've chosen the image shown in Figure 7a, a portrait of the sixteenth US president. Scan an image of your choice and open it to a workspace in your image editor.

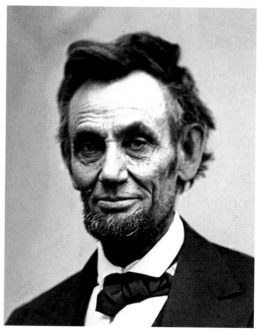

Fig. 7a. Original image.
Photo by Alexander Gardner, 1865. Color editing and derivative copyright by James J. Nance, 2006.
Prints available at www.abrahamlincolnartgallery.com

Afterimage generators work better with fewer target colors, so I am going to remove all but four of the colors from my picture. This will still leave enough detail to produce a clear afterimage. To do this, make the image layer active and perform the following commands:

Image > Adjustments > Posterize . . . Levels: 4

The result of this process is shown in Figure 7b. Increase the number of Levels to include more colors in your image if you wish. However, remember that more colors may require additional charge time.

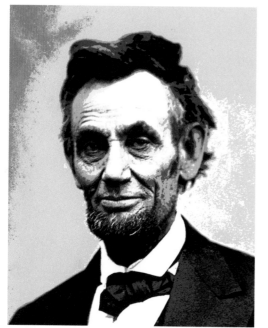

Fig. 7b. Four-color image

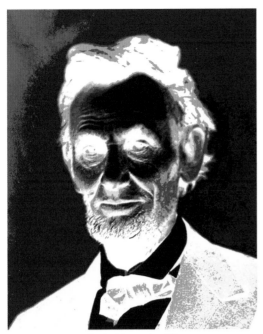

Fig. 7c. Four-color AIG

We're almost done. The final operation is to convert the four-color picture to a color negative. Perform the following commands with the image in an active layer:

Image > Adjustments > Invert

This process results in the image shown in Figure 7c. That's it. We're done. The image editor automatically changes all colors to their opposite or complementary colors. We've created a negative from a positive. The reverse colors in the AIG now make the subject harder to identify. However, a thirty-second charge will produce a realistic, true-color image in the mind's eye.

You will find that some pictures do not work well as AIGs because the subject is too obscure. On the other hand, pictures that are too familiar will be solved easily at first glance. The illusion at the very beginning of this project is a good example of using an obscure image. It depicts the author.

CHAPTER 2
Ambiguous Illusions

Have you ever found yourself responding, "That could mean several things. It depends on how you look at it." If so, you already know a lot about ambiguous illusions. They can be interpreted in different ways too. Each way an image can be viewed is called an "aspect."

Let's look at some examples. Figure 8 contains a well-known ambiguous symbol. Is the circle half-white or half-black? It can be seen either way, and both ways are aspects of the same symbol. If you also see a mouse here, you are well on the path to ambiguous enlightenment.

Some patterns have ambiguous aspects, as shown in Figure 9. Do you see cats? Are they red, or are they black?

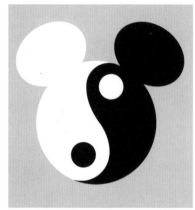

Fig. 8. Yin, yang, or mouse?

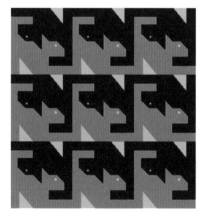

Fig. 9. Red or black cats?

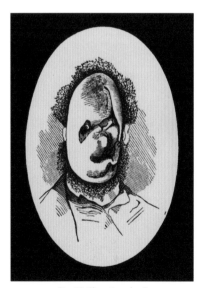

Fig. 10. Sleeping dog?

Figure 10 is an illustration known as *Sleeping Dog*. It looks like a portrait of the Elephant Man to me. So where is the sleeping dog? It's there. You just have to hunt for it. *Sleeping Dog* is our first example of a true ambiguous illusion. It has been specifically designed with a hidden aspect to fool the eye.

To find hidden aspects, first determine what you *can* see. This will probably be the main aspect. Now try viewing the drawing in new ways. Step back and look at the whole drawing at once. Try rotating the image. Look at it from many different angles.

Sometimes an aspect wants to be found, as is the case in the *All is Vanity* illusion shown in Figure 11. At first you see a girl sitting before a large mirror. It is only when you take in the whole drawing that you notice the aspect of a large skull in the background.

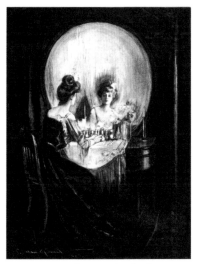

Fig. 11. *All is Vanity,* by Charles Allan Gilbert (1873–1929)

All is Vanity illustrates a challenging facet of drawing ambiguous illusions. Almost everything in an ambiguous drawing must have more than one meaning and serve at least two aspects. It is sometimes difficult to keep it all sorted out.

That ambiguous illusions can have more than two aspects is shown by the illustration in Figure 12. This amazing figure holds the faces of seven clowns. Try to find them yourself before reading the answer below.

Answer: Clown 1 is the obvious figure facing the front; clowns 2 and 3 face right and left; clowns 4, 5, 6, and 7 all face inward and share the same nose as clown 1.

Ambiguous illusions are not always drawn. They occur frequently in nature. A story about some scientists illustrates this point. It seems these planetary geologists were studying an image, the same image shown in Figure 13. They analyzed and measured the image, studied the features, and compared it to all known geologic formations. After some time the scientists finally

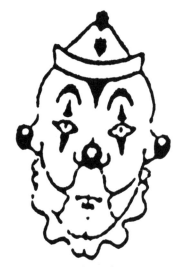

Fig. 12. Seven clowns

concluded that it was an enormous lava dome. Just as they were getting ready to announce their findings, a savvy technician wandered by and casually turned the picture upside down.

When the scientists saw the image this way, they were embarrassed, to say the least. Turn this page upside down to see what the scientists were missing. The moral of the story: question everything.

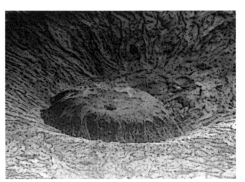

Fig. 13. What did the scientists miss?

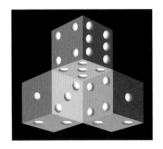

PROJECT 5
Four Cubes

This illusion is called Four Cubes, but you may see only three. That's because the fourth cube is a hidden aspect in the empty space between the three visible cubes. The fourth cube's aspect is inverted and colored gray in the example above. The ambiguity lies in the fact that you either see the empty space as an illusory cube or as nothing at all. The empty space is center stage for either event.

Scan, copy, or trace the template provided in Figure 14a and color it however you wish. Figures 14b–14d illustrate suggestions for color and shading. Try making corresponding faces the same color. When drawing this illusion, ignore the concept of perspective. There isn't any. The point of view should focus on the center of the three visible cubes or thereabouts.

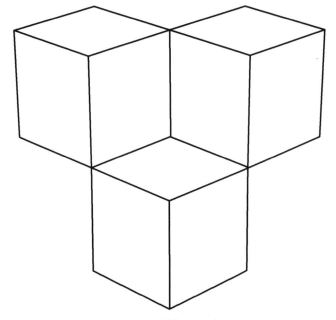

Fig. 14a. Four Cubes template

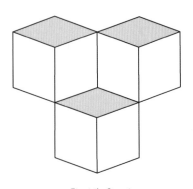

Fig. 14b. Step 1

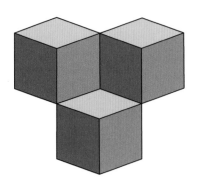

Fig. 14c. Step 2

Fig. 14d. Step 3

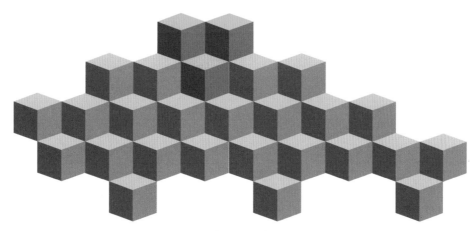

Fig. 15. Ambiguous cube pattern

This design works very well as a background pattern, as shown in Figure 15. Duplicate the cube design and stack them together until you have enough for your purpose.

The Four Cubes illusion works as a 3-D model! Build or sculpt a model of the cube illusion using paper, cardboard, or blocks of wood. Size your model so that it fits comfortably in one hand. To visualize the phantom fourth cube, hold the model so that you are looking directly at the empty space between the steps. Once you can "see" the fourth cube, rotate the model slowly to the right and left. Watch the fourth cube rotate in the opposite direction. This model is totally cool!

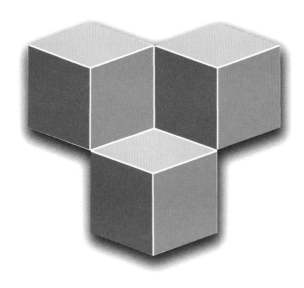

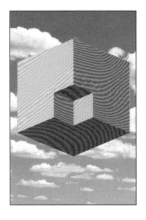

PROJECT 6
Missing Corner

The Missing Corner illusion employs the empty space from the Four Cubes illusion in Project 5 and features the same two aspects. It too can be seen either as empty or as a solid cube. However, the Missing Corner illusion adds a tantalizing third aspect: a small cube in the front.

Visualizing both aspects in the previous project will help you with this illusion. Once you have the first two aspects in the bag, visualizing the third aspect is a piece of cake.

Aspect number 1 in this illusion is the large, solid cube with a small cube-shaped piece missing from the bottom front corner. Aspect number 2 is the large cube visualized as a hollow room with three sides (two adjoining walls and a floor). The small cube, now solid, is tucked into the back corner. In aspect number 3, the large cube is solid once again, and so is the small cube. Visualize the small one as a solid, inverted cube floating in front of the large cube near the bottom.

Figures 16a–16c illustrate a sequence of steps for shading the cube design. Start here and then experiment. Scan, copy, or trace the template in Figure 16d and use it for your own design projects.

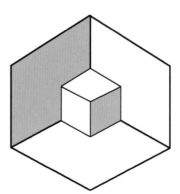

Fig. 16a. Step 1

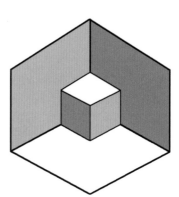

Fig. 16b. Step 2

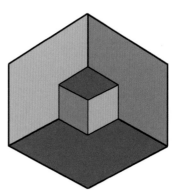

Fig. 16c. Step 3

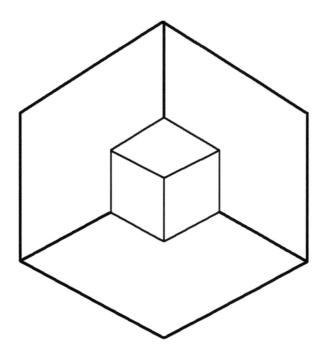

Fig. 16d. Missing Corner template

The Missing Corner illusion works as a 3-D model! Build or sculpt a model of the Missing Corner illusion using paper, cardboard, or a block of wood. Size your model so that it fits comfortably in one hand. To visualize the phantom cube, hold the model so that you are looking directly at the center of the missing corner. Once you "see" the floating-cube aspect, rotate the model slowly to the right and left. Watch the floating cube rotate in the opposite direction.

You can download a 3-D project sheet for this illusion at www.sandlotscience.com/Projects/Illusion_Science_Projects_PDF.htm.

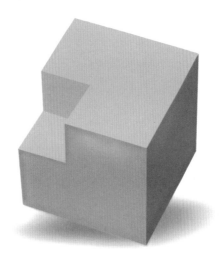

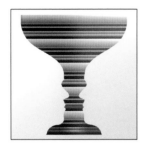

PROJECT 7
Profiles in Stemware

This illusion sports ambiguity with a difference. The main aspect is stemware, in the form of a cup or goblet. The hidden aspect is on the goblet's stem.

To find the hidden aspect, you must look beyond the goblet and consider the background near the stem. In particular, notice the stem's outline. It is doing double duty as a stem and as human profiles. Scientists call this phenomenon "figure/ground confusion." I prefer "figure/ground choices."

The illusion begs the question, are the profiles part of the goblet or part of the background? Not being an expert, I'll put my money on "both" as the right answer. The profiles are on the stem, but their bodies are all background.

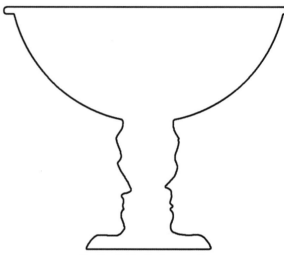

Fig. 17a. Goblet illusion template

Scan, copy, or trace the template in Figure 17a and use it for your own projects. Figure 17b shows the template design filled so you can see the difference and judge how it may affect the illusion.

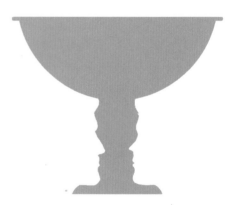

Fig. 17b. Goblet illusion template filled

If you can't draw, you can still create this illusion. Look through illustrated dinnerware catalogs and prospect for telltale profiles. Figure 18 shows an example of a commercial goblet I found with ready-made profiles. This bit of stemware is already an illusion; it just needs someone to call it one! Try using the profiles of your friends too!

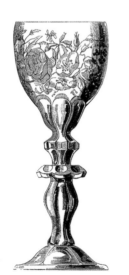

Fig. 18. Commercial stemware

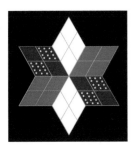

PROJECT 8
Liberty Blocks

Liberty Blocks may add new dimensions to your ambiguous cube designs. The idea here is to use four colorful diamond-shaped blocks to build an endless variety of ambiguous cube patterns. The concept is hardly new since the blocks have been around for almost one hundred years.

The four kinds of blocks required for this patriotic set are provided in Figure 19a. Scan, copy, or trace the templates to make a set of blocks. The size and variety of designs you can make depend on how many blocks you are willing to reproduce. Attach your blocks to heavy cardboard to make them last longer.

Three of the many possible designs are shown to get you started. The US flag motif is optional. You can color your set of blocks any way you wish. In the example shown near the project title, why does the star-shaped design appear folded? Figure 19b shows a design with our old friend the inverted, ambiguous cube aspect. There are eleven cubes: five obvious plus six of the illusory kind. Figure 19c shows an interesting

Fig. 19a. Liberty Blocks templates

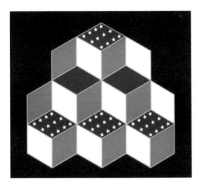

Fig. 19b. Six or eleven cubes?

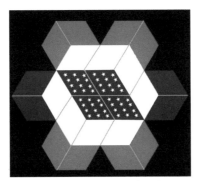

Fig. 19c. Facing up or down?

example with a star-filled surface, which faces either down or up depending upon how you look at it.

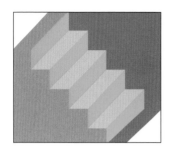

PROJECT 9
Ambiguous Staircase

The Ambiguous Staircase is a reversible illusion that works well alone or as a repeating pattern. In the example above, a blue staircase is the prominent aspect. If you concentrate on the red wall, it is not hard to see the aspect of a second, red, upside-down staircase.

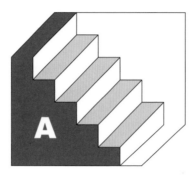

Fig. 20a. Shape A

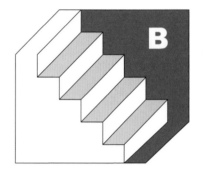

Fig. 20b. Shape B

Figure 20a shows the staircase with the front wall shaded and marked as A. A carpenter would call this a skirtboard or backing stringer. Figure 20b shows the opposite stringer shaded and marked as B. Note that shapes A and B are identical.

Once you have shapes A and B in place, it is simply a matter of connecting the two stringers with lines representing the stairs. Our nosy carpenter will insist that we call these the treads and risers.

The treads and risers in my example are equal. Because it is symmetrical, this design might well be used for a quilting project. You can use any size and any number of steps you wish for your designs.

Scan, copy, or trace the template in Figure 20c and use it for your own design projects. Coloring is optional for this project because the design looks good and works well with or without color.

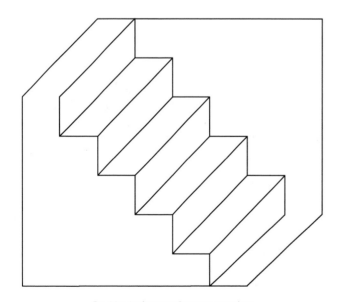

Fig. 20c. Ambiguous Staircase template

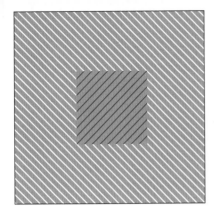

CHAPTER 3
Contrast and Color Illusions

The human eye, in concert with an intelligent mind, can pick out an amazing amount of fine detail from the colors in the world around us. More than 200 million colors in many hues and levels of brightness and saturation are available to us.

So complex is our relationship with color that finding an illusion for them is like throwing a baseball into a china shop. You are bound to hit something. This section will explore a few of the many fascinating and simple ways to make illusions with color.

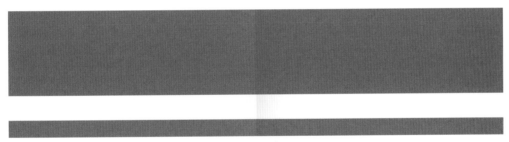

Fig. 21. Color influence

Consider the illusion in Figure 21. It looks like a color swatch with a crease down the center. Ignore the white strip near the bottom for now. The swatch is all the same color. If we compare one half of the swatch with the other . . . but we're not buying it. The right half looks darker.

Now look at the white strip near the bottom. Here a portion of the color has been removed from the swatch so that you can see what is causing the confusion. It reveals a very thin, faint shadow, extending a bit to the right. This is what makes the swatch look like it is folded and causes the conflict in contrast.

So powerful is this little shadow that it influences the entire right half of the swatch. The illusion can easily be canceled. Cover the shadow with a thin strip of paper or your finger. Position it over the vertical "crease." The swatch color will now look the same throughout.

A rule of contrast is that any color looks darker when it is next to a lighter color, and lighter when next to a darker color. If you want a really deep-black cat, get a white one too.

This rule is illustrated in Figure 22a. The central horizontal bar is the same shade of gray along its length, yet we are compelled to see differences because of the shifting background. To paraphrase Frank Sinatra, is it that old devil moon in your eyes or a wily contrasting colorist?

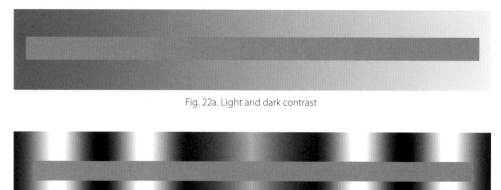

Fig. 22a. Light and dark contrast

Fig. 22b. Washboard contrast effect

A more complicated example of this effect is shown in Figure 22b. The gray bar in the foreground passes through several changes in contrast depending upon what shade is behind it.

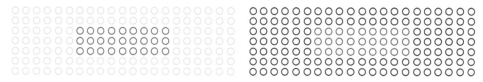

Fig. 23. Red and orange?

A patch of color is always influenced by the colors around it in some way. Figure 23 shows an example of a color-contrast illusion. The red circles are the same in both the right- and left-hand patterns, but the surrounding colors cause contrast problems. The dark blue makes the red circles look lighter, which we see as a color closer to orange.

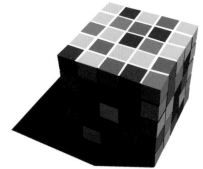

The colorful cube in Figure 24 has one of the strongest color-contrast effects that I have ever seen. It proves our rule of contrast in no uncertain terms. The square in the center of the top face and the square in the center of the front face are exactly the same hue. Cross my heart and hope to get oozing boils, it's true.

This is the power of contrast illusions. The only way you'll ever convince yourself that they are identical is to shove the squares right up next to one another and compare them. Please don't cut up the book!

Fig. 24. Identical squares, based on an original design by R. Beau Lotto

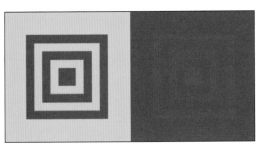

PROJECT 10
Influential Colors

This project will help you explore the bounds of a color's influence. Every color has an influence on colors that are nearby. We observe color influences by comparing one with the other. This illusion will help you find satisfying color combinations to illustrate the power of contrast.

Start by dividing an area with two very different colors such as the light tan and dark brown fields shown in Figure 25a. Next, fill an area within each color field with a third color. I've chosen a sort of khaki green for the example shown in Figure 25b.

You can use any design you wish for the contrast element. Complex designs will work as well as a simple brushstroke. However, avoid designs too intricate or they won't hold enough color to generate the illusion.

The example at the top of the page has a stronger effect than Figure 25b. This is an illusion to keep working on until the perfect colors come

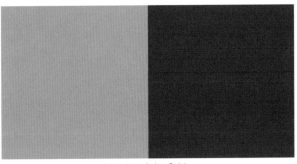

Fig. 25a. Color fields

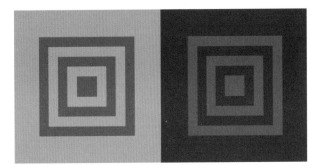

Fig. 25b. Contrasting color

to hand. Try many different variations. Figure 26 shows an example of the illusion with six panels and a heart-shaped design.

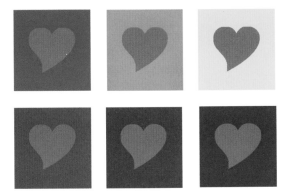

Fig. 26. Hearts in contrast

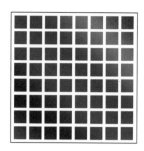

PROJECT 11
Hermann's Grid

The fuzzy dots in the intersections of the color grid above do not exist. They appear as you move your eyes around the grid, and you see them mostly out of the corner of your eye. If you focus on a single fuzzy dot, it disappears.

Nobody really knows why we see the fuzzy dots, an illusion first documented by German physiologist Ludimar Hermann (1838–1914). They could be afterimages because they disappear when you look directly at them. They also could be contrast illusions because the intersections where they appear are the only areas where dark color looms on all sides, a surefire recipe for contrast.

In any case, the illusion just happens. All we have to do is provide an environment where it can do its thing. Almost any grid and any dark color will do. Figures 27a and 27b show how to make a grid by coloring an area then removing material to form the grid lines.

You may even wish to make a reverse grid in which the squares are white and the intersections are dark. What would the fuzzy dots look like in a reversed grid? Try it!

Are the fuzzy dots still visible in the two-color, reversed grid shown in Figure 28?

Fig. 27a. Dark blue

Fig. 27b. Cutout grid

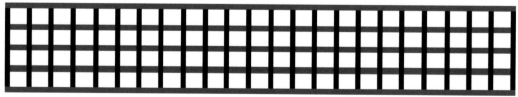

Fig. 28. Are the dots still there?

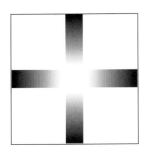

PROJECT 12
Burning Fuses

This contrast illusion produces a stunning effect of brightness. It is aptly named because the center of four conjoining "fuses" seems to burn white-hot. The contrast effect is all done with shadows. The faint halo around the center is a mystery. I don't know where it comes from.

Each arm of the cross contains a gradient, a shadow that fades along the length, from 100 percent black on the outer edges to transparent near the center. This is what causes the illusion. Without gradients, the design looks like Figure 29a.

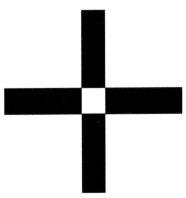

Fig. 29a. Cross without gradients

Because I'm lazy, I use Photoshop to make the gradients. Figure 29b shows the illusion open in a workspace. Here the background layer is painted gray for clarity; your background layer should be white. The marquee shows the current selection. With the foreground color set to black and the Radial Gradient tool set "Foreground to Transparent," apply the gradient. The red arrow within the selection area shows the approximate drag extents to use for the gradient. Duplicate the gradient and apply it to the rest of the arms.

Play with the gradient drag extent. Note that the gradient fades out just short of the intersection. The center appears to burn hotter if it is nearly transparent at this point. The corners where the arms meet should be invisible. Your tool history will probably mirror mine: Drag . . . Undo . . . Drag . . . Undo . . . Drag . . . Undo . . . until you get it right.

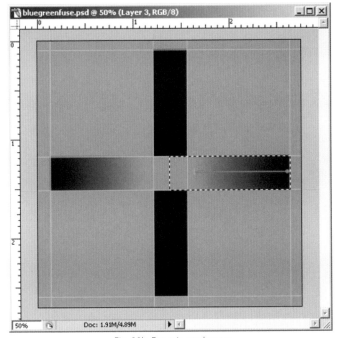

Fig. 29b. Fuses in workspace

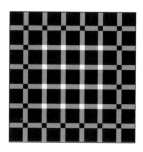

PROJECT 13
Color Spots

If you see light-blue dots in the illustration above, they are phantoms. They appear as the complement of orange and turn white when you look directly at them, so they must be afterimages. The white squares are pockets of high contrast and provide places for the dots to appear.

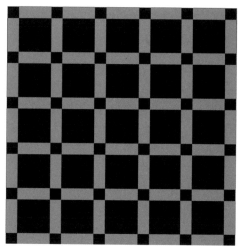

Fig. 30a. Basic grid

If you have just come from Project 12 you will notice that the cross element in this design is the same as that one. In this design the cross is used to make a grid pattern.

First, make a grid like the one shown in Figure 30a. The color of the grid will determine the color of the after-image dots. For this example I've chosen the color green. The phantom dots should appear in the complement of green: pinkish red.

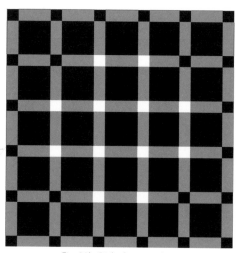

Fig. 30b. Pink phantom dots

Once the grid is complete, the idea is to turn a certain number of the little black squares into little white squares. The number of white squares you make should be based on the size of your grid and the pattern you've chosen to use. An octagon-shaped pattern is used in Figure 30b.

At least one square must be white or the illusion won't work. Experiment with different colors in the grid to produce different colored phantom dots. Is it possible to make this illusion grid with multiple colors and generate multiple afterimage colors? Try it!

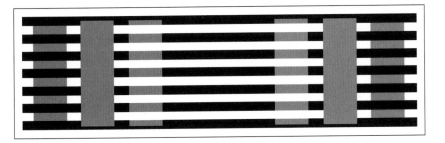

This illusion will demonstrate contrast effects for single or multiple colors. The colors can be any hue you wish. The illusion will present three levels of contrast effects for each color used: behind, above, and interwoven in a series of black bars.

To create this illusion, start with parallel black bars on a white background, as shown in Figure 31a. This example has equally spaced bars. The grid is about half black and half white overall, a safe range.

Next, place three identical rectangles over the grid, as shown in Figure 31b. At this point, all three rectangles appear to be the same shade.

Drop one rectangle behind the bars by removing color where the black bars would otherwise pass over. That rectangle now has more black color around it and will appear darker in contrast.

Leave one rectangle on top of the bars. This rectangle, surrounded by equal amounts of black and white, will remain the true color.

"Weave" the last rectangle by removing color where the white bars would otherwise pass over. This rectangle is now surrounded mostly by white and will appear to be lighter in contrast.

The end result, seen in Figure 31c, is not only a great illusion and demonstration of contrast; it is also an excellent example of how to make one color look like three!

Fig. 31a. Parallel bars

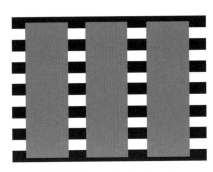

Fig. 31b. Three colored rectangles

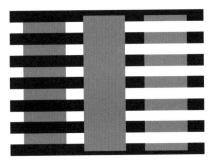

Fig. 31c. Color contrasts

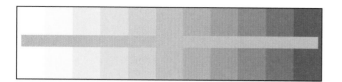

This illusion allows you to display a wide range of contrast effects for a single color. In the sample above, there are ten shades of cyan plus white. Each vertical panel, starting with deep cyan on the right, is about 10 percent lighter than the previous panel. The center panel is 50 percent cyan. It is color-matched to the control bar running across the center of the design. Even though we know the color is the same throughout, the ends of the control bar appear to be different shades of cyan.

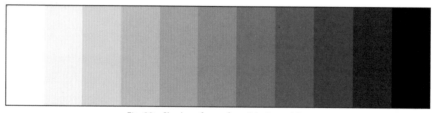

Fig. 32a. Shades of gray, from black to white

Figure 32a shows the same panels in black to white. From the far right panel, which is true black, the panels descend in 10-percent steps. The last panel on the left is true white. The center column is color-matched to the control bar, as shown in Figure 32b.

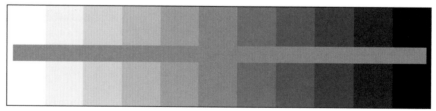

Fig. 32b. Control bar matches center panel

Have fun with this one. Mix the panels up; what happens to the control bar? How do different colors work? Will a rainbow of colors at one time work?

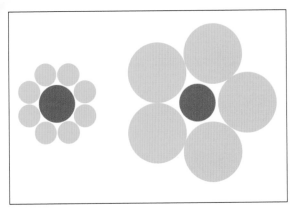

CHAPTER 4
Distortion Illusions

What is normal? Every day we humans decide on an unconscious level what is normal. We categorize the universe according to a mental list of boundless rules: the sky is up; the earth is down; and so on. We can challenge these rules with distortions. Theoretically, for every "normal" phenomenon, there is a way to fool the mind's eye. The possibilities are endless.

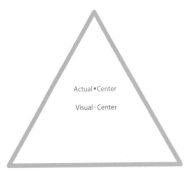

Fig. 33. Actual versus visual center

Consider the triangle in Figure 33. The purple dot is located at the exact center of the triangle. Call this point the actual center. It doesn't look right, does it? The mind's eye wants to put the center much lower, near the gray dot. Call this point the visual center. Once someone points out such a discrepancy, it becomes known as an illusion, a description made even more official when scientists begin to explain the effect. It is a lot harder to explain distortion illusions than to draw them, which is good news for us.

If Figure 33 were a box instead of a triangle, the actual and visual centers would merge, and all would be right with the world. The triangle's sloping sides cause the illusion. They draw the mind's eye inward and make us fumble spatial estimates.

Every object in the universe has an actual and visual center. These centers are sometimes the same and sometimes different. When an object's centers are different, it causes a distortion illusion. The number of illusions possible for this one variety of distortion alone is virtually infinite.

A rule that is corollary to the triangle distortion is that a vertical line intersecting a horizontal line of the same length will appear longer. The rule and resulting distortion are illustrated in Figure 34. Ancient artisans knew this rule, if not in words then

Fig. 34. A rule of lines: vertical distortion

in practice. Artists always seem to know these things. The placement of the lines makes the blue one look longer, when it is not. A straight-edged ruler is a must-have tool for the distortion buff.

Figure 35 shows an improvised version of the rule of lines in a popular illusion known as Lincoln's Hat (which just goes to show you how long some illusions have been around). Despite appearances, the hat is as wide as it is tall.

The Mystic Wheel distortion shown in Figure 36 was done in Photoshop. The only part that should look three-dimensional is the marble in the center. The wiggly spokes should appear flat; instead

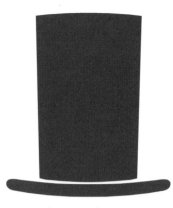

Fig. 35. Lincoln's Hat

they create obvious ridges and hollows around the wheel. How the wheel distortion works is a mystery to me, but I love it. There are surely millions of geometrical distortions waiting to be drawn.

Figure 37 is a digital painting that uses a pyramid instead of a triangle to produce the same distortion as in Figure 33. It must seem by now that I couldn't find the center of a bucket with a flashlight. But I really can. It is simply the nature of distortions.

Grab a ruler and prove me wrong!

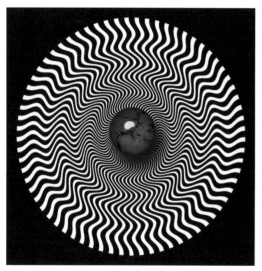

Fig. 36. Mystic Wheel

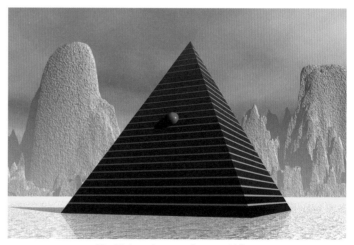

Fig. 37. Actual center of a pyramid face

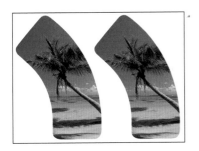

PROJECT 16
Banana Cards

Banana Cards are one of the best pocket illusions ever made. This self-starting, easy-to-do illusion consists of two cards similar to those shown above. An amazing distortion happens when you compare them. The cards are identical, yet the one on the left looks bigger.

Because of a built-in banana-shaped bend, each card comes with a long curve and a short curve. If you place the cards on a table with opposing curves facing each other, you cannot resist the urge to assume that the longer curve must belong to a bigger card. But if you place the cards on the table with similar curves facing each other, the illusion stops. There will be no distortion, and the two cards will look identical when compared.

Trace, copy, or scan the template provided in Figure 38 to make your own Banana Cards. Color or decorate them to suit your purpose. Cut out the cards carefully because you may need to demonstrate that they are identical to skeptics when you show them off. Mount them on heavy cardboard to make the cards easier to handle and last longer.

Consider this illusion for business cards or advertising handouts. People tend to love them, take them, keep them, and use them.

Fig. 38. Banana Cards template

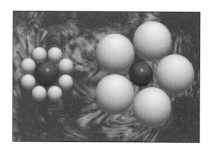

PROJECT 17
Titchener's Dots

The Titchener effect, first documented by psychologist Edward B. Titchener (1867–1927), is based on how we compare groups of objects. This version with dots or balls works well as a strong and consistent distortion illusion. The two red balls above are the same size, but the one on the left looks a bit bigger.

The quirk in perception happens because we can't help comparing the red balls with their groups before we compare them with each other. The result reveals a slight flaw in our ability to size things in groups.

Figure 39a shows two red balls, minus groups. The balls are the same size and spaced apart to allow room for accompanying objects. Figure 39b shows the Titchener illusion complete, with groups in place. At this point the illusion will work continuously until the ink fades from this page.

Fig. 39a. Identical red balls

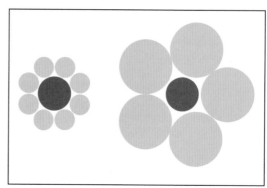

Fig. 39b. Titchener illusion

The shape, color, and number of objects in each group have no effect except aesthetic, which makes the design possibilities endless. The only requirements are that the two groups must be separated, and their respective objects must have an obvious size difference. Generally the bigger the difference between groups, the stronger the effect.

You can construct the illusion out of paper plates, river rocks, plastic cups, rubber balls, jacks, daisies, sunflowers, or fat dollops of ketchup and mustard. Be the first to make Titchener-illusion beverage coasters!

 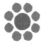 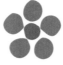 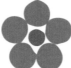 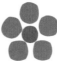

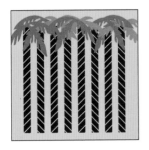

PROJECT 18
Crooked Columns

The simplest things can become illusions. The columns serving as palm-tree trunks in the example above give the impression of being tilted. The effect is very slight and very much an illusion. If the candy-cane stripes were slanted in the same direction or if the columns were blank as in Figure 40a, there would be no distortion illusion.

This illusion starts with a series of vertical bars, as shown in Figure 40a. Add candy-cane stripes to the columns in opposite directions, as shown in Figure 40b.

Changing some of the design elements will affect the distortion illusion, though color does not matter as long as you can see the stripes. Experiment with different column widths and lengths. Vary the number of columns. Also try different stripe angles and thicknesses. Think of the stripes as mortar between bricks. One way to affect the distortion illusion is to use less or more mortar.

To make this a tabletop demonstration, cut the columns out of cardboard. First show the cutouts with the stripes all in one direction with no illusion. Then turn every other cutout upside down to present an instant illusion.

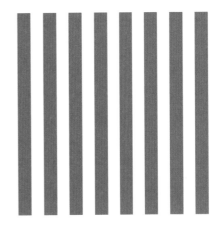

Fig. 40a. Parallel columns

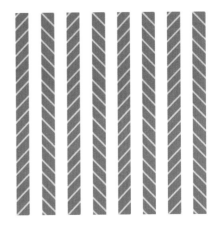

Fig. 40b. Crooked lines

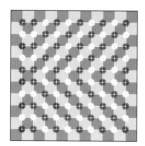

PROJECT 19
Distorted Checkerboards

The checkerboard is a pattern familiar to us all. We know that the squares should look neat and tidy like the pattern in Figure 41a. Here is a way to give a common checkerboard an eye-popping bulge by simply adding some distortion points. These distortions will appear as phantoms in our mind's eye.

Start with a checkerboard like the one in Figure 41a. Use any colors you wish and make the pattern as big as you wish. Figure 41b shows how to add distortion points. The points can be any color or shape you wish, such as dots, squares, etc. Experiment to see what works best. The tiny white stars used in this example appear to work well.

Pick any dark square on which to start placing points. Here we started around a square indicated as point A in Figure 41b. Place points as shown. They spread outward like ripples in a pond. This pattern is what causes the bulge.

This is a fun illusion to draw because you see the pattern bulge as you continue adding points. The checkerboard goes from normal to distorted right before your eyes. Each new design produces a unique effect with this illusion. Below are several experimental patterns using various distortion points, colors, and design elements.

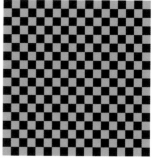

Fig. 41a. Normal checkerboard pattern

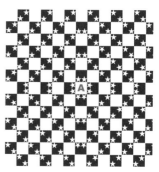

Fig. 41b. Checkerboard with distortion points

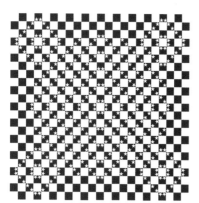

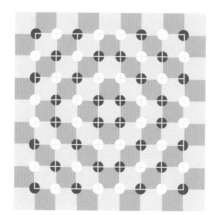

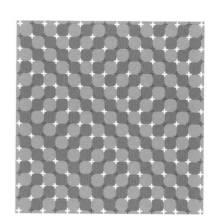

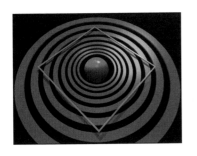

PROJECT 20
Square in Circles

Here is another distortion that is caused by object comparison. This time it's a square against a circle. To make it interesting, we'll give the circle power in numbers. In the example above, a red square is placed above numerous circle shapes.

So powerful is the impression made by the circles, the square doesn't stand a chance. The mind's eye is lulled and pulled inward by every nearby curve, making the sides of the square appear slightly bent.

Figure 42a shows a plan view of the circle team, a stout system of concentric rings. They should have more visual weight than the square. Figure 42b shows the doomed and soon-to-look-bent square. It is important that the square have straight sides. Don't cheat. Place the square over the circles, as shown in Figure 42c. Voila!

This illusion would make a nice display from an overhead projector. Explain that you are about to demonstrate the magnetic power of concentric rings. Be sure to have a straight-edged ruler handy.

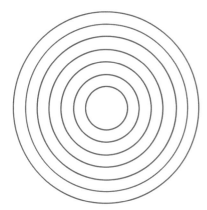

Fig. 42a. Mighty circles

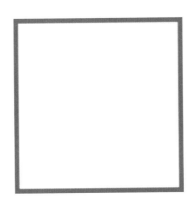

Fig. 42b. Doomed square

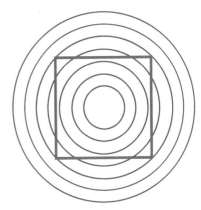

Fig. 42c. Square loses

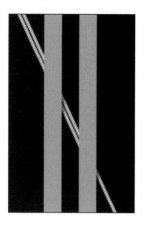

PROJECT 21
Poggendorff's Distortion

This illusion will leave you wondering how we ever learn to read maps. In the example shown above, which of the two ropes goes from the top all the way to the bottom? If you picked the lower rope, you are completely normal and completely wrong. The upper rope goes from the top to the very bottom.

If the two ropes were oriented to pass perpendicularly across the gaps, we would have no trouble connecting their lengths. It is the steep angle that defeats the mind's eye. The steeper it gets, the more confused we get.

The example shown in Figure 43 is the classic Poggendorff illusion, discovered by German physicist Johann Poggendorff (1796–1877). Most people pick the blue line when it is really the yellow that connects to the white.

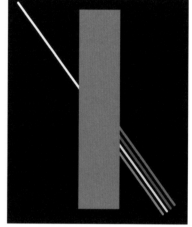

Fig. 43. Poggendorff illusion

To make a simple Poggendorff, start with two lines. Give them a steep angle, as shown in Figure 44a. Cut one of the lines short as shown. Hide the spot where the short line ends, as shown in Figure 44b. A narrow rectangle seems to work well. Experiment with different ways to present the deception.

Fig. 44a. Naked truth

Once the mask is in place, it is hard to tell where one line stops and begins. We are pretty good at mapping paths across gaps, but not so good when the path involves a steep angle.

Fig. 44b. Confusion

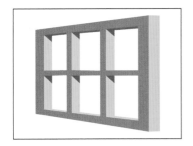

PROJECT 22
Ames Trapezoid

The basic shape of this illusion is trapezoidal, with one end narrower than the other. This trapezoid can be turned into a powerful and dynamic handheld distortion illusion. When rotated, it will refuse to spin!

Named after American visual-perception scientist Adelbert Ames Jr. (1880–1955), and created by American illusionist Jerry Andrus, this illusion starts by imagining the trapezoid as one face of a foreshortened box. Thus, in the view shown above, the taller end is nearer. The illusion of perspective is greatly enhanced by making the shape look like a three-dimensional object. For this project,

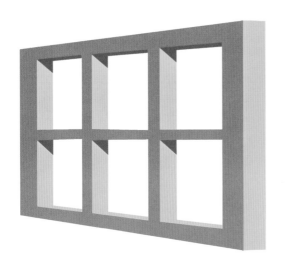

Fig. 45a. Ames Trapezoid: front and back templates

we'll simulate a 3-D window frame, as shown in Figure 45a.

Copy, scan, or trace the two templates. Carefully cut out the two shapes and glue them back to back to form a double-sided card. Before you attach them together, insert a small stick or straw into the bottom of the card to use as a handle. Make sure both sides are right-side up. Cutting out the windows is optional.

Fig. 45b. The "trapezoid stare"

Hold the card in front of your face at eye level, then rotate the window at a moderate, steady pace; see Figure 45b. The window should rotate in a complete circle, but it appears to oscillate back and forth like a freaky pendulum! Keep the rotation as smooth as possible. Experiment with rotation speed to achieve the strongest effect.

The illusion works because the 3-D appearance of the window is more powerful than the actual rotation of the card. We are swept away by the illusion of an oscillating three-dimensional window. It is almost impossible to see the wide edge of the window pass beyond the farthest point of its orbit, because by then we are focusing on the reverse side of the card, which is now visible and moving in the opposite direction.

The double-sided card can be made almost any size. Only the shape is important. Attach a large trapezoid to a variable-speed motor, and you have an instant stage show. The 3-D object it represents can be any that fits into the trapezoid's profile.

You can see an animated Ames Trapezoid at www.sandlotscience.com/Distortions/Ames_Trapezoid.htm.

CHAPTER 5
Impossible Objects

Impossible objects may look normal at first, but they ultimately fail a reality check. The longer you look at them, the less convincing they appear. Anyone who is on friendly terms with what is normal can easily ferret out an impossible object. They stick out like a brown shoe in a world of tuxedos.

Consider the three-dimensional object in Figure 46a, which happens to be a normal triangle. One could easily build this object. It reeks of normal and passes the reality check with flying colors. Now compare Figure 46a with Figure 46b. At first we may assume that the new object shares many features with the normal triangle. But then, like hunters who know the forest well, we become suspicious. "Something's wrong here."

What's wrong is that this new object is an impossible triangle. A general shape is about all the two objects share. Figure 46b is twisted beyond redemption; corners meet where they shouldn't, and it acts like a Möbius Band. Part of an impossible object's mojo is that it cannot be constructed in real life. Solid materials cannot go together as they do in Figure 46b, at least not in this universe. Except in the narrowest of terms, impossible objects can exist only in drawings.

Figure 47 bears some resemblance to a window or picture frame, but it has the same twisted geometry as the impossible triangle. Looks reasonable at first . . . but how can the top and bottom crosspieces face in different directions?

Figure 46a. Possible

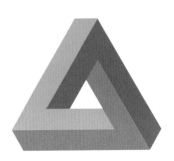

Figure 46b. Impossible

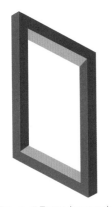

Figure 47. Twisted rectangle

Figure 48. Twisted circle

Figure 48 takes an impossible design one step further by twisting a doughnut shape into an impossible circle. To further muddy the waters, the outside has been shaved to form a hexagonal surface.

Impossible objects all possess some fatal flaw in geometry or perspective that makes them fail a reality test. The flaws cannot be hidden, but you sometimes have to look closely to find them. In this section of the book, we'll show you some simple ways of drawing impossible objects that won't make you lose your grip on reality.

Some impossible objects hide behind very subtle clues. The object shown in Figure 49 has an elusive nature. Is it impossible or

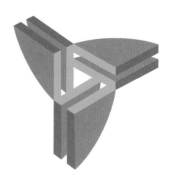

Figure 49. Impossible?

not? Let's take a closer look. If the three pairs of pie shapes are identical, then this is an impossible object. Any two of the pairs can be set up this way, but a third could not possibly fit as shown.

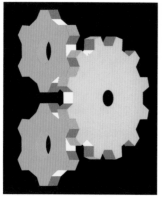

Figure 50. Devil's Fork

Figure 50 is an example of the Devil's Fork, or impossible trident design. It begins as two prongs and ends as three. The trident flagrantly shares contours between features. This object could exist only on paper.

Many contour-sharing illusions defy colorization. The Devil's Fork has areas where color can be contained within borders, while other areas leak into the background and will not hold color.

Figure 51 shows an exception to this color rule. The three gear elements share contours and shape, but since the geometry remains angular overall, the surfaces can contain color. The shared contours occur at the points where the small gears mesh with the large gear. These points represent both a tooth of the small gear and a space between teeth of the large gear. Sounds ambiguous, huh?

Figure 51 does contain ambiguity. Still, overall it looks, draws, and acts like a contour-sharing impossible object. A 3-D model of the gears would look like an impossible object only from this unique angle. This viewing angle is the single exception to the "no-build" rule of impossibility. You can build models of most impossible objects, but everybody will have to look at it from one point of view. Modelers call this sweet spot the "Ames Transformation."

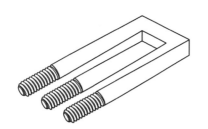

Figure 51. *Gearosity.*
Original drawing by D. Simanek

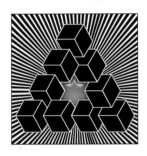

PROJECT 23
The Tri-bar

The Tri-bar, in the words of British mathematician Roger Penrose, "is impossibility in its purest form." Swedish artist Oscar Reutersvärd, who first realized the design, also gave us a way to draw it without going nuts. The following method should help avoid many of the pitfalls of drawing the Tri-bar, or impossible triangle.

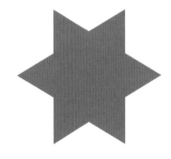

Figure 52a. The star

Figure 52a shows a stubby, six-pointed star. The interior angle of each point is 60 degrees. The star's shape is important because it will serve as a blueprint for the design. The star may be discarded once the design is complete.

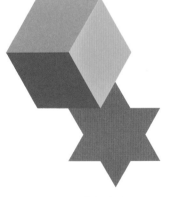

Figure 52b. The cube

Figure 52b shows the cube that we will repeat nine times for this design. The cubes are rotated 30 degrees from vertical because they have to dock with the star as shown in Figure 52c. Make sure your cubes fit snugly in the spaces between the points of the star.

Place the first six cubes around the star as shown in Figure 52d. Start with cube 1 and overlap the cubes as shown. Higher numbers should overlap lower numbers. Stop for a moment at cube 6. Cube 6 is the keystone. In a realistic design, it would overlap cube 1 and come farthest into the foreground. Tuck it behind cube 1 instead. The assembly is now impossible.

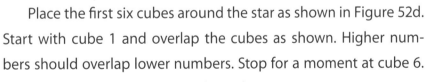

Figure 52c. Cube docking

Tucking cube 6 behind cube 1 adds a twist to the overall structure and turns it into a true impossible object.

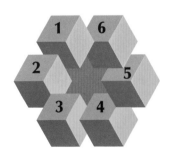

Figure 52d. The first step

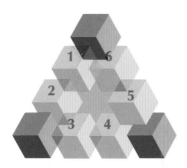

Figure 52e. Corner cubes

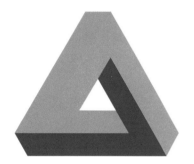

Figure 52g. Solid triangle

The design could stand on its own at this point. However, to complete the Tri-bar, continue with the following steps.

Place the last three cubes into their corner positions, as shown in Figure 52e. Place the cubes so they overlap as shown and are aligned with the cubes on either side.

Figure 52f shows the complete triangle of nine cubes with the blueprint star removed. Convert the cube triangle to a solid by filling in the spaces between cubes. Note that the finished Tri-bar in Figure 52g has

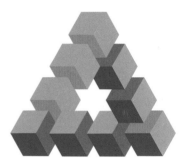

Figure 52f. Complete triangle

three identical L-shaped surfaces arranged around the central triangle. Paint these three continuous surfaces with complementary colors to enhance the illusion and to complete the design.

Once you become familiar with the Tri-bar design, you can quickly construct impossible triangles using this technique. Copy, scan, or trace the templates provided in Figures 52h and 52i to use in your own design experiments.

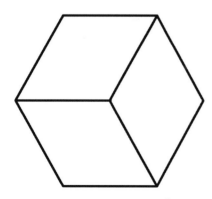

Figure 52h. Cube template

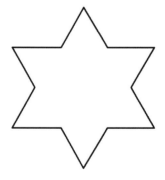

Figure 52i. Star template

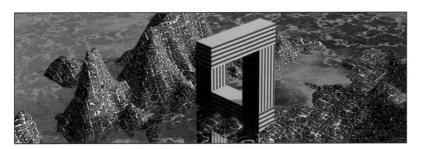

PROJECT 24
Impossible Square

The Impossible Square is the Tri-bar with an added bar. The design is very similar to that of the Tri-bar, pretty straightforward and easy to do. This project outlines a method to draw one half of the frame while the other half draws itself.

The first step is to draw half of a normal rectangular frame, as shown in Figure 53a. Make sure that the six vertical lines are equally spaced, including those in the center. You can draw the top or bottom half, but make sure to shear the ends of the lines as indicated.

Next, copy the results of Figure 53a and rotate the copy 180 degrees. If you flip the copy upside down, remember to flip it horizontally as well. Line up the two copies as shown in Figure 53b. Once the two halves are joined, the square is complete: half twisted and quite impossible. Note that the square in Figure 53b contains two basic J shapes that are identical. If you are lazy like me, this may come in handy with future designs. The square in the example by the project title and the one in Figure 53c use the same template as Figure 53b, but the squares are shorter and reversed right to left. The top of the square is now visible and should be rendered as indicated.

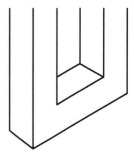

Figure 53a. Step 1

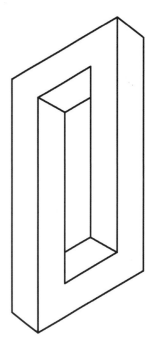

Figure 53b. Step 2

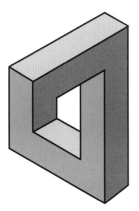

Figure 53c. Short square

The number of design variations for the Impossible Square is undoubtedly infinite. If you follow these instructions, every last one of them will be twisted beyond reality.

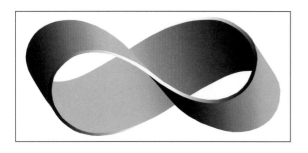

PROJECT 25
Möbius Band

The Möbius Band, named after German mathematician August Ferdinand Möbius (1790–1868), is not impossible. However, it sheds light on the impossible nature of some objects. Follow any surface on a Möbius Band, and you will end up where you started. Oddly enough, the Möbius Band acts very much like an impossible object.

You don't draw the Möbius Band; you make it from scratch. However, the difficulty level of this project is roughly equal to falling off a log: very easy and not nearly as painful. To make a Möbius Band, join the ends of a paper ribbon together as shown in Figure 54. Add a half twist to the ribbon before you glue or tape the ends together. Be careful here. A full twist will turn it into something akin to a Slinky, and no twist will produce a well-crafted headband. Be sure to make the ribbon long enough so that the two ends can come together without cramping the loop.

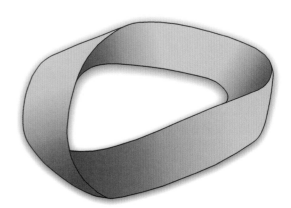

Fig. 54. Ribbon with a half twist

The nature of the Möbius Band is that despite being a three-dimensional object, it has only one side and one edge. Test the band by drawing a line down the center, along the entire length. Start anywhere. You'll cover every surface and eventually end up back where you started.

An impossible object such as the Tri-bar acts very much like the Möbius Band. This is hard to test, since you can't hold a Tri-bar and draw lines around it. However, if you have a steady eye and a little patience, it is possible to imagine a line that touches every surface of a Tri-bar and returns to the starting point.

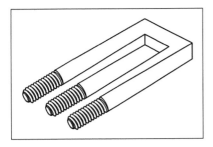

PROJECT 26
Devil's Fork

The impossible trident, or Devil's Fork, is extremely popular with Earthlings. Not that I have shown them to a large sample of Martians; I'm just saying that the fork is the most familiar of a variety of illusions known as contour-sharing impossible objects. The contour lines of these objects do double duty within the same design. Since this is impossible in real life, the object is impossible.

Start the Devil's Fork in the same way as the Impossible Square in Project 24, by drawing one half of a rectangular frame. You can draw the open rectangle in any orientation, but make sure to space contour lines equally, as shown in Figure 55a. Extending the contour lines may help make the illusion look more realistic. It's up to you. In any case, divide the open contour lines into three groups of two. Shear off the ends perpendicular to the lines, as shown in Figure 55b.

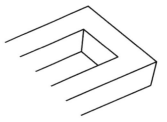

Fig. 55a. Start with an open rectangular frame

The only thing left to do is "cap" the ends of our paired contour lines to make them look like dowels or rods, as shown in Figure 55c. Experiment with different oval or elliptical shapes until you get a believable one. Position the ovals so that they are perpendicular to the paired lines and fit them into place.

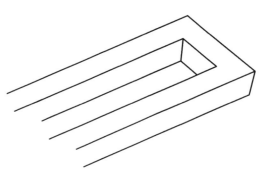

Fig. 55b. Adjust length and shear

The Devil's Fork, or impossible trident, is now complete. Note that it is still an open design. Some areas are bounded and will hold color, while other

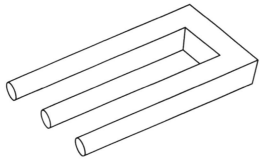

Fig. 55c. Finished trident

areas are open and will "leak" color into the background. Coloring the design can be a challenge. However, it is easy to add minimal shading, as indicated by the example shown in Figure 56.

Figure 56 also illustrates the endless possibilities of the basic design. You can make as many rods and prongs as you wish. Use the impossible trident design to draw candleholders for Christmas cards or perhaps a menorah for Hanukkah. Figure 56 looks like a plan for an impossible leaf rake, or it could be part of a pipe organ or a fancy calliope. I've added American Standard threads to the trident shown at the beginning of this project to make it look more like a proper industrial part.

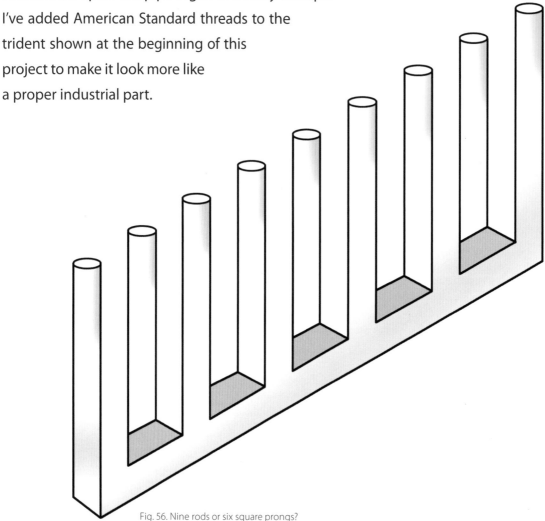

Fig. 56. Nine rods or six square prongs?

CHAPTER 6
Subjective Artifacts

Subjective artifacts have no power or substance of their own. They exist entirely in the mind's eye, subject to individual whims.

For example, we may see a human face in a rock. It is easy to pick out enough familiar features to recognize a face in Figure 57. The face is created in the mind's eye, out of rock and our accumulated knowledge of human anatomy. Subjective illusions are easy for humans to visualize because each of us knows volumes about the visual world. We are especially familiar with faces. We see them everywhere: in rocks, wallpaper patterns, flowers, clouds, and even on the Martian surface.

Fig. 57. Face in a rock

Fig. 58. Subjective words

Figure 58 shows a simple trick artists often use. The words "Cast Shadow" do not exist. The letters are merely suggestive shapes formed by the gray cast shadows. You might say that subjective illusions are "subject" to the things around them.

To see subjective illusions, look first at what is real, such as the three red gel doodads in Figure 59a, which look a bit like old Pac-Man video characters. The red doodads are real enough. However, the triangle hovering in the center of the design is not real. The triangle exists only in the mind's eye, but it seems so real that one can almost see straight lines forming the missing parts. When the Pac-Man characters close their mouths, they merely distort the familiar triangle shape.

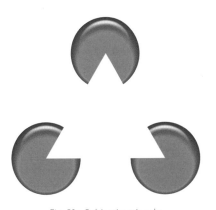

Fig. 59a. Subjective triangle

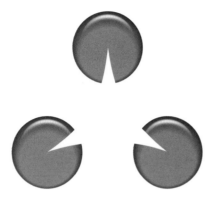

Fig. 59b. Distorted triangle

The subjective illusion remains persistent. Do you visualize straight lines in the missing parts of the triangle in Figure 59b or curved lines?

Figure 59c shows a similar design, only this time it produces a subjective square shape. Once again the illusion is amazingly persistent even though the missing parts of the square are assembled out of whole cloth. Figure 59d, on the other hand, produces a mixed bag of subjective shapes. In this case we can agree on general contours, but the overall meaning of the shape depends on individual quirks. I see the subjective shape in Figure 59d as a 1956 Motorola console TV, a conclusion that is cooked in my own demented mind. Your interpretation of the artifact may be quite different.

Figure 59e shows an example of a subjective shape in a more complicated structure. The doodads are different, but the illusion remains. The Pac-Man shapes are now pinwheels and somewhat harder to see. Their mouths are black, but they still define a subjective shape. What shape do you see in Figure 59e: a snowflake, a sun symbol, a giant asterisk, or a six-pointed star?

Subjective illusions that suggest basic shapes are the easiest to work with because of our familiarity with common imagery. The less one knows about a subjective artifact, the harder it will be to find.

These are, by no means, the only effects possible in the world of subjective illusions. You will find some amazing examples to try in the following projects.

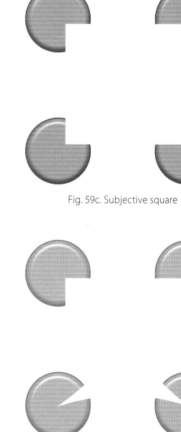

Fig. 59c. Subjective square

Fig. 59d. Mixed shapes

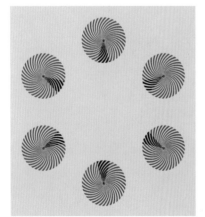

Fig. 59e. Subjective star

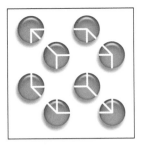

PROJECT 27
Necker Cube

The subjective artifact for this illusion will be the Necker Cube, named for the nineteenth-century Swiss crystallographer who first created it. The Necker Cube is an ambiguous design because the two large panels on the front and back can reverse positions at will. However, for this illusion we can make use of its familiarity as a popular illusionary icon.

Draw the Necker Cube as shown in Figure 60a, or use the template provided. When your Necker Cube is ready, apply eight opaque circles to the intersections of the cube, as shown in Figure 60b. Center the circles on the intersections and make them all the same size. Choose a color that will contrast with your background.

Fig. 60a. Necker Cube template

Now for the hard part: use a well-sharpened eraser to carefully remove any parts of the cube not inside a circle. Reverse the color of any line that is inside a circle so that it matches the background color, as shown in Figure 60c. The Necker Cube is now officially subjective.

Decrease the circle size to make the illusion harder to see, or increase it to make it easier to see.

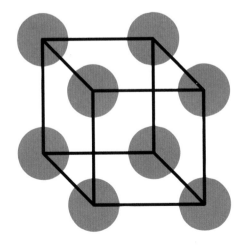

Fig. 60b. Add circles

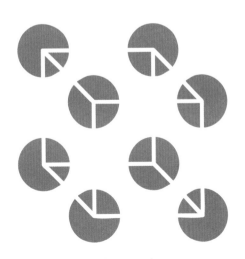

Fig. 60c. Reverse and erase

PROJECT 28
Glowing Square

The subjective square design has umpteen possible variations. This project will outline the basic idea through the construction of a sample form. Once you grasp the rudiments, you can take this idea to the moon, designwise.

Figure 61a shows the core of the design: four sets of concentric circles. I made one set of circles to my satisfaction, then copied and aligned the sets as shown. In Figure 61a, my guidelines and selection area are still visible. The circle shapes could easily be modified to appear as solid orbs, pinwheels, or four-leaf clovers. I chose this design because I wanted to see what radiating arcs would look like on the corners of my subjective square.

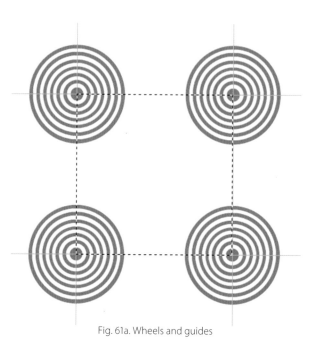

Fig. 61a. Wheels and guides

I got a little more than I bargained for in the final step. As shown in Figure 61b, I lightened the color in the selected area by about 50 to 60 percent. Immediately the subjective square popped out of the image, and something else besides. The inner area of the square seemed to be lightly tinged with the color from the corners. Why was it leaking from the circles? Turns out it's caused by something called "neon color spreading" in illusion-speak. You can look it up, really.

So there you have it. A subjective square, with some kind of freaky, illusory color! The world really is weird.

Fig. 61b. Finished design

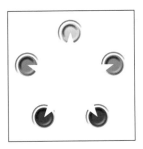

PROJECT 29
An Almost Star

The subjective star may seem too simple to be a serious illusion. But if you consider how little of the star is actually subject to scrutiny, it is amazing that we see it at all. The subjective star illusion may be proof of our intimacy with familiar shapes, like a loved one that we recognize instantly from afar.

Fig. 62a. Basic star

If you have been through Project 28 then you already know the basic drill for this design. Start with a star shape, as shown in Figure 62a. The star doesn't have to have five points. You can rotate the object to any angle that looks pleasing. You may even choose to render this illusion in three dimensions.

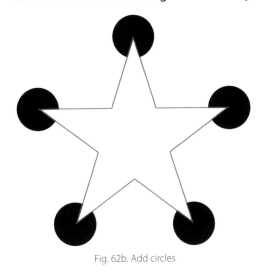

Fig. 62b. Add circles

For this example, place circles behind all the points of the star, as shown in Figure 62b. They don't have to be circles, nor do they have to "reveal" a specific amount of star. Experiment with different shapes and colors.

Finally, remove every trace of the star, as shown in Figure 62c. The subjective star is complete.

The strength of the illusion depends on how much you reveal. As more of the star is revealed, the subjective effect decreases.

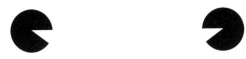

Fig. 62c. Final cleanup

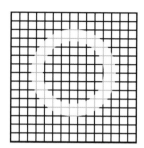

PROJECT 30
Bleeding Doughnut

The subjective circle illusion above exists only by virtue of colored parts of the grid. Less than half the circle bears color, yet the impression of a circle is undoubtedly strong. The illusion is made even stronger because the circle is bleeding color. The entire circle appears to be tinted light blue.

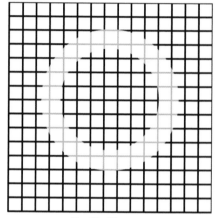

Fig. 63a. Close-up

The bleeding effect is a neural/optical phenomenon called neon color spreading, in which color inside the subjective circle appears to bleed into nearby white spaces. Interestingly, color bleeds freely within the circle, but not outside. The doughnut's outer edges appear crisp and clean—a clear case of internal bleeding!

Figure 63a shows a close-up of the illusion. Even at this size, the effect of bleeding is apparent, and the subjective illusion of a circle remains strong. The grid and circle templates used for this illusion are provided in Figures 63b and 63c. Copy, trace, or scan the templates to use for your experiments.

Figure 63d shows the same illusion with different colors. Play around with various colors and grids in your designs.

Fig. 63b. Grid template

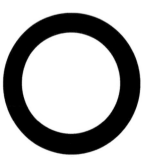

Fig. 63c. Doughnut template

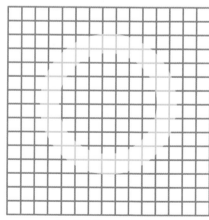

Fig. 63d. Orange frosting

CHAPTER 7
Games and Puzzles

This section presents various nuggets from my collection of favorite spare-time activities. Here you will find a series of problems, constructs, and puzzles for the pencil-wise and the curious. These illusions are designed to help you practice the fine art of wasting time while exercising the noggin in a single fluid motion.

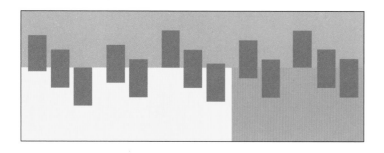

This puzzle starts with thirteen green cards arranged so they span three colored rectangular fields. Each of the three colored rectangles contains various amounts of the green cards.

Copy, trace, or scan Figure 64a, and carefully separate it into three puzzle pieces. You should end up with a long light-blue piece, a medium-size yellow piece, and a short purple piece. Be sure to cut carefully so the puzzle pieces fit neatly together once again.

Place the pieces as shown in Figure 64a and make sure

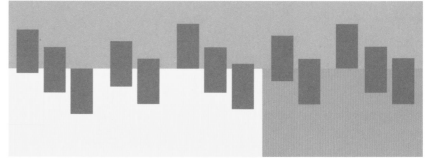

Fig. 64a. Thirteen green cards

there are still thirteen cards. Now rearrange the yellow and purple puzzle pieces: yellow on the right, purple on the left, as shown in Figure 64b.

Fig. 64b. Twelve green cards

Count the green cards again. Only twelve cards! Can you find the missing card?

Answer: When the two puzzle pieces are swapped, the total area of the green cards is also redistributed. The amount is equal to one green card. The thirteenth card has been absorbed by the remaining twelve.

You can see an interactive version of this puzzle at www.sandlotscience.com/Games/Missing_Card_Game.htm.

PROJECT 32
Illusion Word Search

I can't get enough of word searches. See page 70 for the solution.

```
J  W  Q  T  L  R  Y  N  E  Y  D  E  W  C  G  O
W  S  U  O  U  G  I  B  M  A  R  T  P  T  W  T
E  V  I  T  I  U  T  N  I  R  E  T  N  U  O  C
H  L  E  L  B  A  T  S  N  U  V  Z  W  I  O  E
L  X  E  G  S  S  E  L  D  N  E  Z  I  M  X  F
J  V  P  P  A  V  R  B  R  Y  R  Z  P  P  D  F
C  R  E  N  J  M  B  X  E  Q  S  L  X  O  F  E
O  C  W  C  P  H  I  T  A  U  I  W  D  S  K  R
T  Y  D  M  A  H  S  R  D  M  B  F  H  S  L  E
E  A  J  W  A  A  A  K  E  P  L  I  Q  I  U  T
B  L  Z  U  R  A  M  N  R  T  E  E  E  B  R  F
J  B  B  T  M  Z  T  O  T  J  F  G  W  L  Z  A
W  G  N  I  G  A  L  F  U  O  M  A  C  E  M  I
N  O  I  T  R  O  T  S  I  D  M  R  P  H  U  X
C  L  A  Y  C  A  J  Z  A  F  J  I  Q  M  A  R
R  T  K  I  N  V  N  O  I  T  O  M  I  F  F  B
```

AFTEREFFECT	COMPLIMENTARY	MINDREADER
AFTERIMAGE	CONTRAST	MIRAGE
AMBIGUOUS	COUNTERINTUITIVE	MOTION
ASPECT	DISTORTION	PHANTOM
CAMOUFLAGING	ENDLESS	REVERSIBLE
COLOR	IMPOSSIBLE	UNSTABLE

DIOXIDE

There is something special about the word DIOXIDE. This word and words like it are known as "ambigrams." They can be read in another direction or from another perspective. The letters that make up DIOXIDE are vertically symmetrical. The bottom of every letter is a mirror image of its top. If you flip all the letters upside down, as they would appear in a reflecting pool, the word will read the same.

Ambigrams like this work most commonly only with capital letters. In other words, DIOXIDE works, but dioxide doesn't. How many symmetrical ambigrams can you think of? Here are some examples to get you going: HOOD, CODE, DECK, EXCEED . . .

Symmetrical ambigrams are a natural phenomenon; however, not all ambigrams are natural. One small group of artists has proven that word symmetry can be engineered. Chief among these innovators is the American typographer John Langdon. Figure 65 shows Langdon's engineered ambigram *Seasons*. The word is not a natural ambigram. Yet here the artist has forged asymmetrical letterforms into a pleasing, easy-to-read symmetry. In fact this ambigram reads the same backwards! If you rotate the word 180 degrees (that is, turn the book upside down), you will see that it is also a true symmetrical ambigram. The design becomes a metaphor for four seasons, occupying the same place at different times.

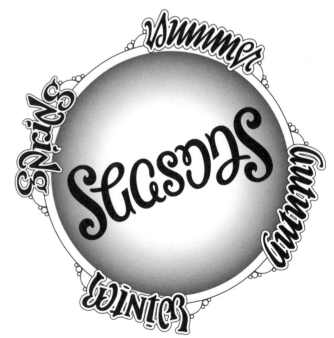

Fig. 65. An engineered ambigram, by John Langdon

The symmetrical ambigram *Seasons* is from John Langdon's book *Wordplay*. For more information, see the list of suggested readings at the end of this book.

PROJECT 34
Jigsaw Juju

This illusion could also be called "Where Did the Hole Go?" It is a pocket trick of misdirection and geometric cunning. Amaze your friends by making a sizeable hole appear and disappear at will.

The effect starts with a simple jigsaw puzzle. The pieces are arranged so that a hole is prominent in the center. With deft agility, you quickly rearrange the pieces, and the hole suddenly disappears.

To perform this feat of magic, first copy, scan, or trace the Juju template in Figure 66a. Carefully cut out the four puzzle pieces. Discard the white piece in the center to form the hole.

Arrange the four pieces on a table as shown in the template. Point out the hole and ask if anyone can rearrange the pieces to eliminate the hole. No takers? It looks impossible.

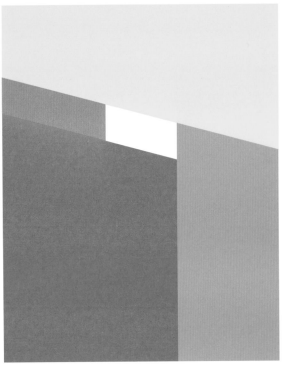

Fig. 66a. Jigsaw Juju template

Flip all four puzzle pieces over on their backs, right to left, as shown in Figure 66b. They should remain in their relative positions. Make sure that the orange and red pieces do not change locations. When the red and orange puzzle pieces are flipped properly, they will form a cavity that fits the blue piece perfectly. Slide the blue piece to the right and down. Slide the yellow piece down to complete the solid block. The hole is gone!

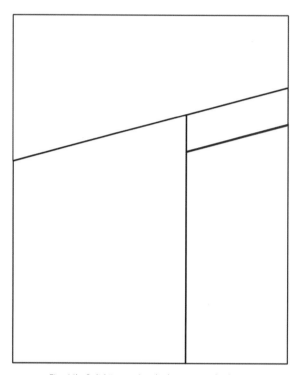

Fig. 66b. Solid jigsaw (cards shown upside down)

The effect works because the four pieces fit differently when they are flipped upside down. The puzzle shrinks in size by the exact amount of the hole. It is a geometric certainty. If you don't mention the size difference, nobody will notice.

Rehearse your puzzle-piece-handling skills to make this illusion look smooth and practiced. Mount the puzzle pieces on heavy cardboard to make the illusion more durable and easier to handle.

PROJECT 35
BrainSquid 1

A classic optical illusion has been accidentally shredded into many little pieces. Can you help rescue the design? Technicians have carefully tagged each piece of the puzzle with its coordinates. Your challenge is to reconstruct the design by sketching the contents of each box in its proper place on the grid. See page 68 for the solution.

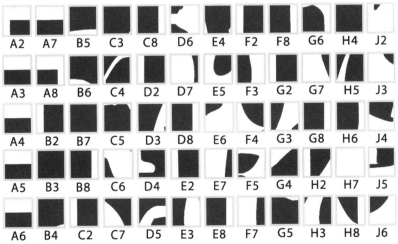

PROJECT 36
BrainSquid 2

A classic optical illusion has been accidentally shredded into many little pieces. Can you help rescue the design? Technicians have carefully tagged each piece of the puzzle with its coordinates. Your challenge is to reconstruct the design by sketching the contents of each box in its proper place on the grid. See page 69 for the solution.

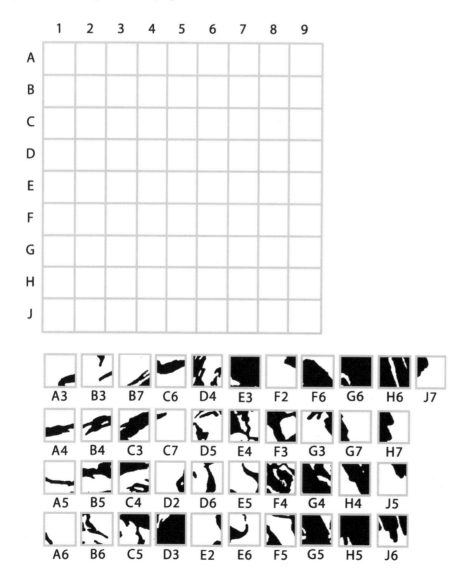

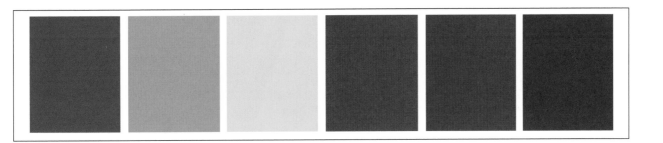

PROJECT 37
Stroop Tests

Humans have had the ability to see colors for millions of years. We are extremely good at it. Stroop tests are a fun way to pit this powerful color sense against a relatively new human accomplishment: the ability to read. Something strange and wonderful happens when we take Stroop tests. Our reading skills interfere with our ability to identify colors, causing our minds to become tongue-tied and uncertain.

The Stroop effect, discovered by American psychologist John Ridley Stroop in 1935, can be demonstrated with three short tests. The first test measures our ability to identify colors. The second measures our ability to read the names for colors. The third test is a mixture of the first two, and the most revealing. Time the tests and compare results for each person.

You'll need some blank flash cards, color markers, and a way to time the tests. Use simple colors such as the six shown above. These colors are red, orange, yellow, green, blue, and purple. Use the same colors and color names for all three tests.

You don't have to use a set number of cards for each test, but don't use too many or your subjects might get bored. Twelve is a nice round number. This way you can make two cards for each of the six colors in the tests.

Fig. 67a. Test 1 sample

PURPLE

Fig. 67b. Test 2 sample

Fig. 67c. Test 3 sample

Test 1 is a See Color test. Mark these cards with color swatches only, as shown in Figure 67a. Test 2 is a Read Color test. Mark these cards with the names for the colors. To make test 2 easier, print each color name in that particular color of ink, as shown in Figure 67b.

Test 3 is another See Color test . . . with a twist. Mark these cards with the words for the colors as in test 2, but print each color name in one of the other five colors.

Shuffle the cards for each test, and ask subjects to give their answers out loud. Subjects will do very well on tests 1 and 2. At this point, remind subjects that test 3 is a SEE test, not a READ test. They should ignore the word and instead concentrate on the color. For example, the correct answer to the sample card in Figure 67c is "yellow."

Reading skills will hamper anyone taking test 3. They may hesitate or read the word out loud instead of announcing the correct color. This is a fun way to start a discussion about perception.

Suggested Readings

Block, J. Richard. *Seeing Double: Over 200 Mind-Bending Illusions.* London: Routledge, 2002.

Combs, Karen. *Optical Illusions for Quilters.* Shelton, CT: Image Graphics, 1997.

Ernst, Bruno. *The Eye Beguiled: Optical Illusions.* Cologne: Benedikt Taschen, 1986.

Escher, M. C. *The Graphic Work of M. C. Escher.* Translated by John E. Brigham. New York: Meredith Press, 1960.

Jollands, David, ed. *Sight, Light and Color.* Science Universe Series. New York: Arco, 1984.

Langdon, John. *Wordplay: Ambigrams and Reflections on the Art of Ambigrams.* New York: Harcourt Brace Jovanovich, 1992.

Wick, Walter. *Walter Wick's Optical Tricks.* New York: Scholastic, 1998.

Also see Robert Ausbourne's interactive illusions on the Internet at www.sandlotscience.com.

BRAINSQUID ANSWERS
BrainSquid 1

The answer to this puzzle is a silhouette of the famous *Mona Lisa*. It is also a working afterimage generator. Stare at the red dot for about ten seconds, and then look at the white areas of this page. A positive afterimage of the painting will form in your mind's eye.

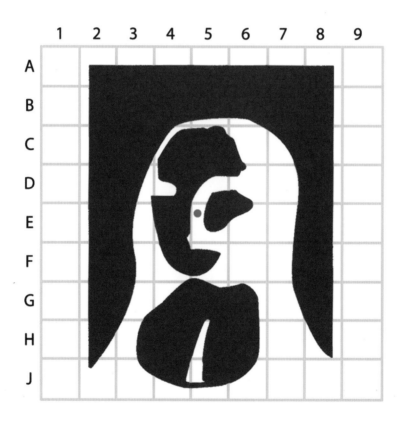

BrainSquid 2

You have restored an ambiguous illusion called *My Father and My Son*. This hundred-year-old cartoon portrays both a father and a son. Can you find them both? The old man's lips form the top of the young man's neckerchief. The old man's eye is the young man's ear.

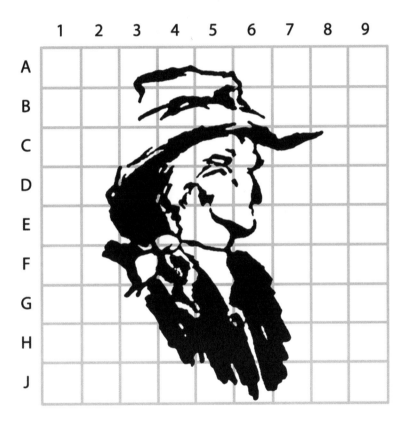

ILLUSION WORD
SEARCH ANSWER

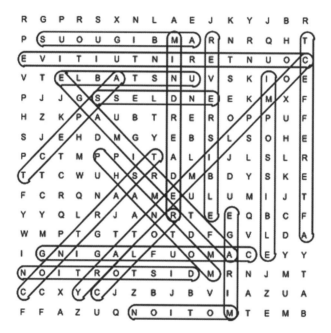

Tech Notes

Tech Notes